A Brush with
CATS

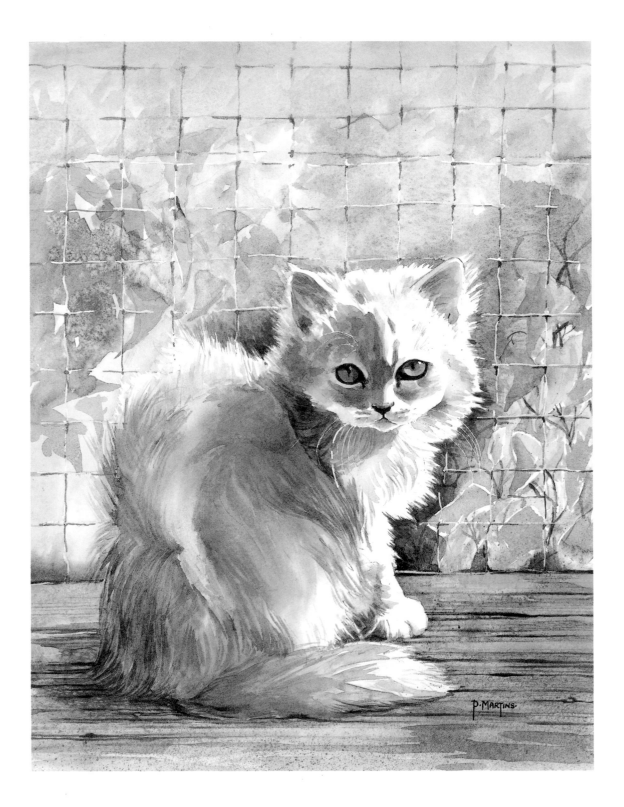

A Brush with
CATS

Pam Martins

SOUVENIR PRESS

To my family:
Terry, Joanna, Pippa, Jim, Mandy, Greg
and the little boys

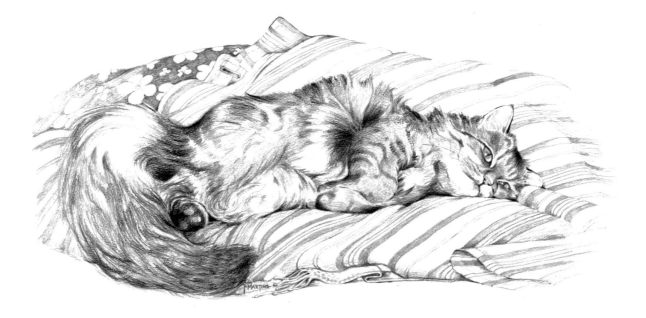

INTRODUCTION

So many cats, so many characters. Every one is so different and each cat seems to have the ability to adapt to the lifestyle of its owner — or is it the other way round?

I spend a lot of time studying these fascinating animals and have come to love and admire them, and to realise that many other people share my obsession. This book presents just a few of my feline friends and their human companions.

Whenever possible, I travel around with camera, sketch-pad and a few watercolour paints. When I spot a likely puss I first take a photograph — to ensure that I get a permanent record before I lose sight of my model — and then, given the opportunity, I try to make a sketch and colour notes. It is wonderful if I find that I am welcome to return to further my acquaintance with the cat and to learn something of its life story. Most people are very helpful and only too glad of an excuse to chat about their own special feline. I have made many new friends in this way.

Armed with all the material I can gather, I return to my studio to produce a watercolour of the cat. These pages show some of the results.

I hope that this book will give pleasure to cat lovers everywhere. Perhaps it will also kindle an interest in the few people who are less enamoured of cats, those who have yet to discover the joys and sometimes (it must be said) exasperations of sharing their homes with these exquisite, lazy, comfort-loving, sometimes affectionate, always mystifying animals.

PAM MARTINS

SANDY
The Station Cat

There is a small branch-line railway station near my home in South Devon, neat and clean, with a wooded area behind it and bright flowerbeds lovingly tended by the station master.

His house is nearby, and when he walks to work each morning his little cat Sandy pads along behind him. They arrive quite early, in time for the milk train.

Sandy is a tabby, with soft yellow-ochre underparts. During the summer months he stays contentedly on the platform throughout the day, but when the weather turns colder he usually wanders back home to enter through his cat-flap, and settles down in the warmth to await his owner's return.

When I have to make a train journey, I try to arrive in good time to have a few words with Sandy and to stroke his soft coat to make him purr — which he does almost at once. A very pleasant start to any journey!

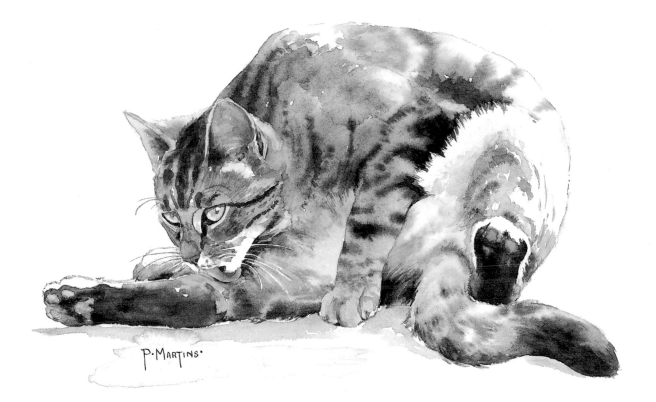

P. Martins·

BENJIE
The Play-School Cat

The school-room in a village near where I live is quite small and is run by two women who take in a few under-fives, mornings only. They live on the premises and Benjie belongs to them — jointly.

He is a ragged little kitten, growing fast, but he is still full of mischief and loves to get inside things. The children make a great fuss of him, but he has become very adept at avoiding too much handling and usually manages to slip away from small tail-pullers and molesters.

I succeeded in taking some photographs of him one day as he emptied a shopping bag and plunged inside — playing real wild-cat games. This painting is the outcome.

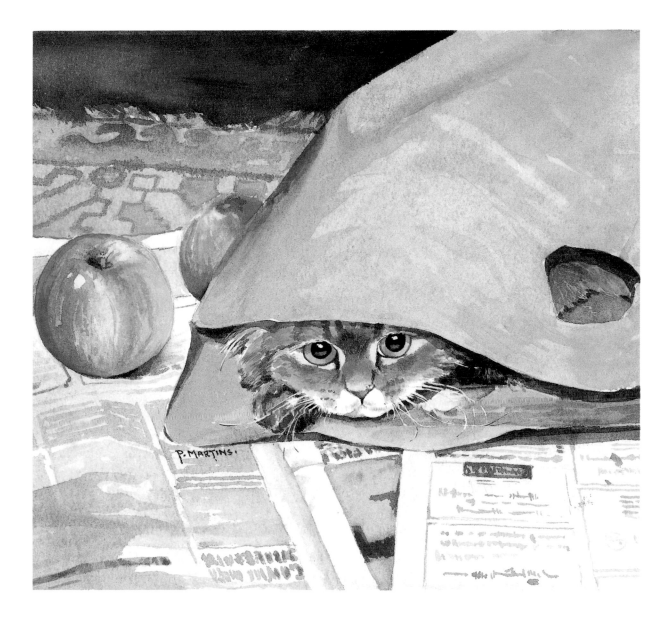

MORRIS
The Garage Cat

Morris is white and fluffy, which makes life very difficult for him as he lives with the owner of a garage and spends most of his time on the forecourt. Washing seems to be his main occupation, and on one occasion when I found him busily cleaning himself I made some quick drawings of him.

Inevitably there is a lot of oil and grit about, but Morris always looks sparkling white and really seems to enjoy the bustle and comings and goings of the vehicles. He is quite careful, however, and keeps well away from the danger zone. The regular customers always look out for the busy little white cat.

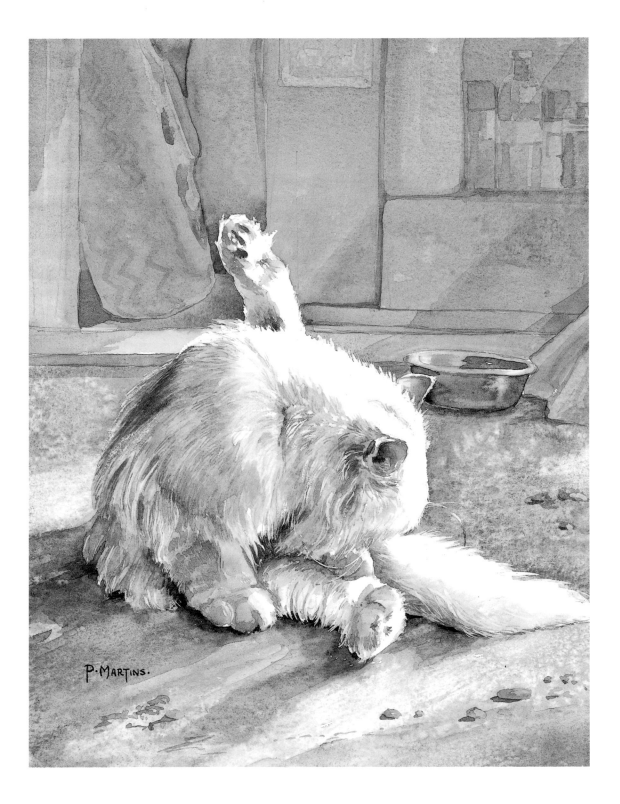

SIMON
The Fisherman's Cat

Simon is a tabby cat who has it made. He is cared for by a fisherman and leads a great life, sleeping in the boat-house and enjoying the pick of the left-over fish and bits of crabmeat.

His sybaritic existence has made him rather lazy, and he is not too conscientious about the washing and grooming routine so that he tends to look a trifle scruffy.

One day I found him lying on the boat's deck, relaxing in the sun after a good feed and smelling somewhat fishy. He seemed disinclined to move, so I was able to make a quick sketch and colour-wash of him to work on later.

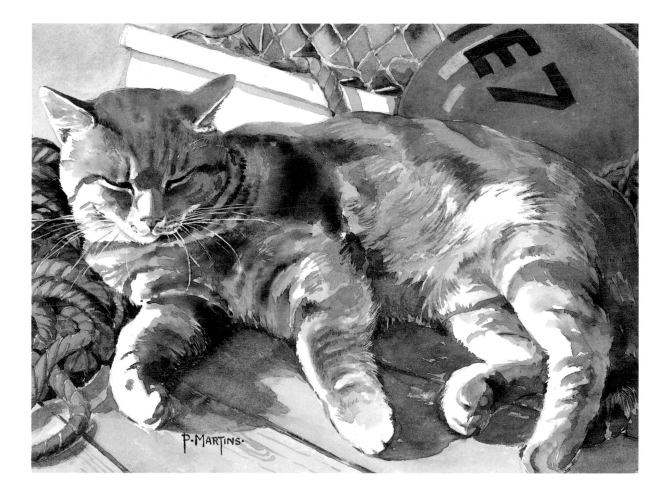

TOSCA
The Teacher's Cat

Tosca is a 'rescued' cat. She was found abandoned in a cardboard box, a small damp bundle. Someone took her to the local branch of the Cats' Protection League where she was cared for and given treatment by the vet.

She grew into a pretty, long-haired cat with mottled tabby markings, and was eventually adopted by a retired teacher who had a genuine love for cats.

Tosca has a very desirable semi-wild garden in which to hunt and play, and she comes running when she hears the small hand-bell which the teacher rings for her at mealtimes. She can often be found in her 'secret' place among the catkins, and this is where I chose to paint her.

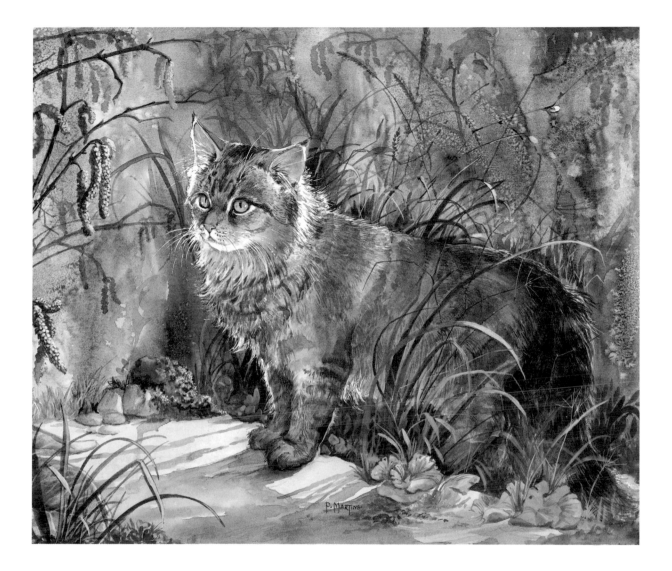

SOPHIA
The Show Cat

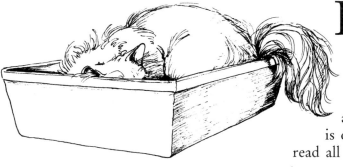

I often attend cat shows, grand affairs with rows of cages, each containing a pure white blanket, drinking water, a clean litter-tray — and of course a beautifully shampooed, brushed and groomed show cat (very often curled up asleep in the litter-tray!). The cat's number is on the cage, and in the catalogue one can read all about him: his long, exotic name, his category and pedigree.

The cats are amazingly calm, and most look as if they positively enjoy all the admiration, attention and publicity.

This little gem, named Sophia, is a long-haired white kitten, the best in her class. She won a rosette for her beauty.

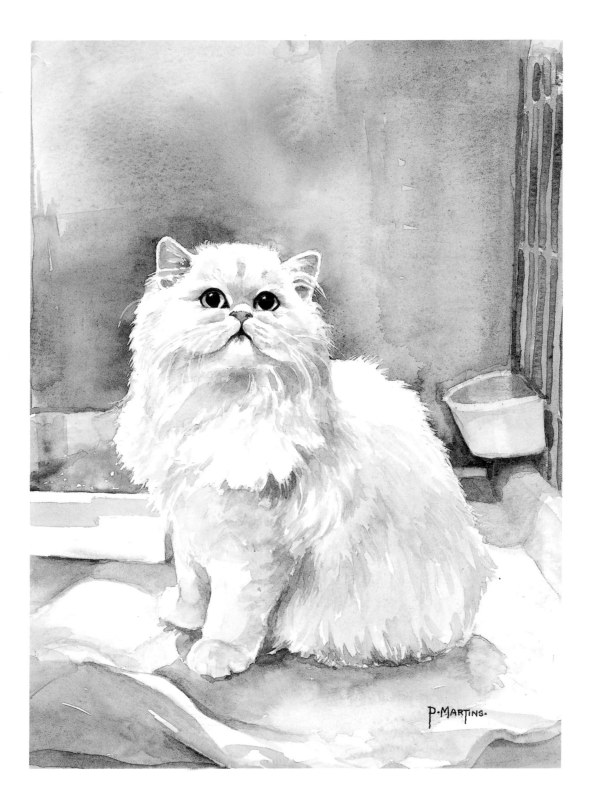

FUDGE
The Hotel Cat

Fudge is a rather old cat now and has lived all his life in a small hotel.

He likes to spend the day sitting on his favourite chair in the hall, where he can view, in comfort, the arrivals and departures of the guests. I once stayed there for a short while, and as he was nearly always to be found dozing on his cushion, I managed to do a painting of him.

The hotel owners told me that he just wandered in one day, thirteen years ago — a young ginger cat — and simply took them over. No one claimed him, so he settled in and became a permanent guest — bed, breakfast and evening meals!

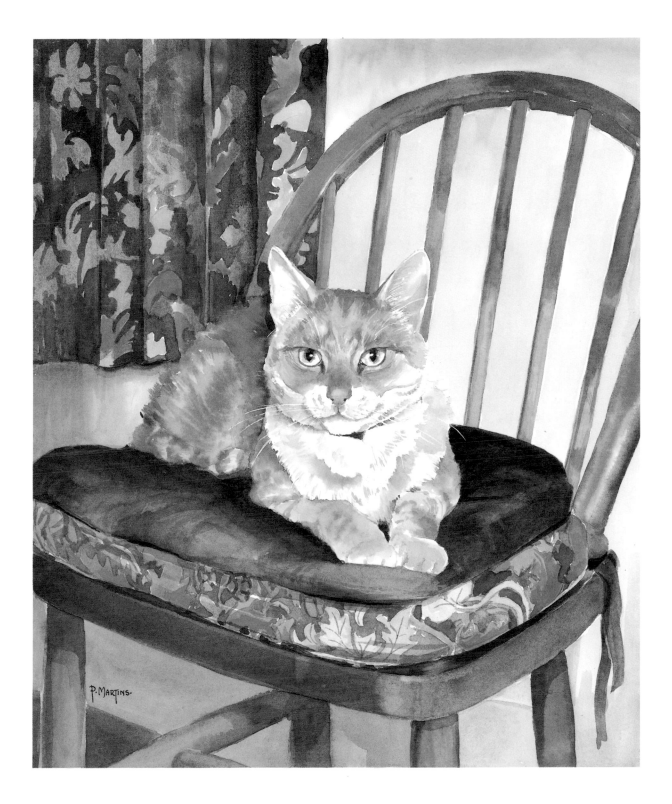

TIGGER
The Farm Cat

Tigger lives on a nearby farm. There are other cats there, of course, but Tigger is King. He is getting on a bit now and is rather battle-scarred — ears torn, nose scratched and coat on the rough side.

He has more than earned his living over the years, catching many mice and keeping the other cats in order. I suspect, too, that he is father to most of the farm kittens.

Where humans are concerned he is a friendly old chap, and always pads over to greet me when I visit the farm. He rubs against my legs — perhaps because he knows I usually have a small 'cat-treat' in my pocket for him.

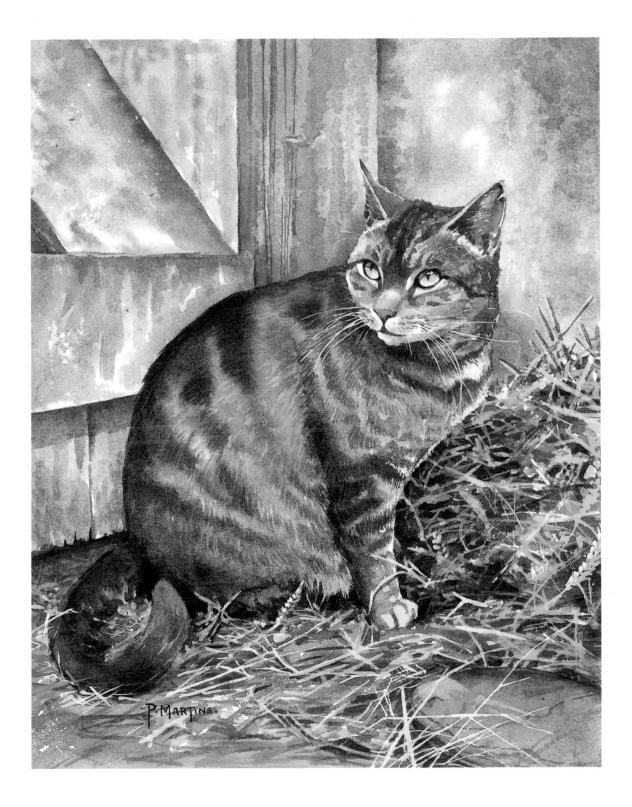

P. Martins.

PUSSY-WILLOW & EBONY
The Lock-Keeper's Cats

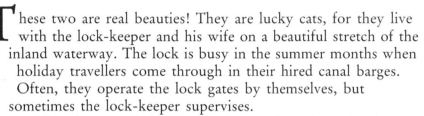

These two are real beauties! They are lucky cats, for they live with the lock-keeper and his wife on a beautiful stretch of the inland waterway. The lock is busy in the summer months when holiday travellers come through in their hired canal barges.

Often, they operate the lock gates by themselves, but sometimes the lock-keeper supervises.

Willow loves to lie basking in the sun, but Ebony is a hunter and goes stalking along the tow-path and through the long grass on the canal bank.

The two cats seem to love each other and always sleep curled up together. The winter months are spent by a log fire — sleek fur and long, long legs and tails entwined.

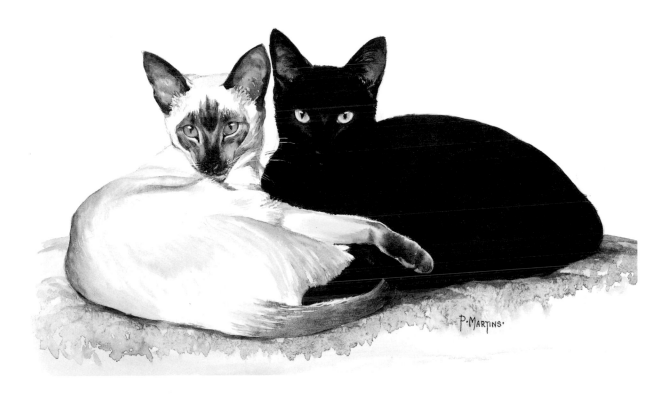

MABEL
A Neighbour's Cat

Ifirst saw Mabel when she was quite young — a sprightly little black-and-white kitten. She lives with a neighbour whose garden borders mine.

Mabel has a companion, a West Highland White Terrier named Daisy. They get on very well together and harmonise beautifully — a symphony of black-and-white.

Mabel has grown up now, but she is still not very big and I think she will always be a small cat. I often see her at an upstairs window, her pure white bib shining clearly, gazing between the curtains into my garden where she can watch my own two cats, George and Minnie.

I think she is rather shy, for I have never seen her wandering into my garden, but she is much loved and her mistress and I have long cat-chats over the hedge. This picture of Mabel was painted when she was still just a kitten.

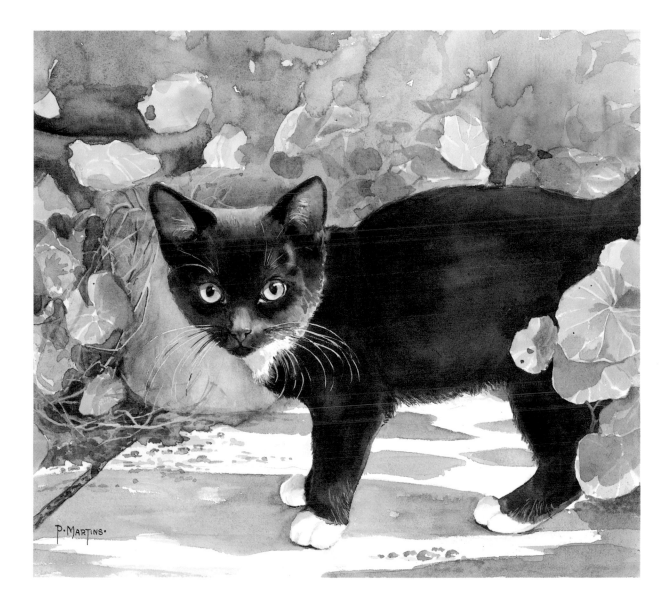

'NO-NAME'
The Hatherleigh Cat

Wandering around Hatherleigh in Devon, with my sketch-pad and camera, I came across a garden where a woman was busy weeding. Close by, her little white cat was curled up, peeping at me through the long grass.

With permission, I took a photograph and managed a quick drawing before my small model flitted away.

I made this painting and a year later returned to Hatherleigh. Being unfamiliar with the place, I searched high and low for the garden and the owner of the cat.

Eventually I did find a similar garden, but on enquiring was told, 'Sorry, no white cat here — ever!'

Did she really exist, I wonder?

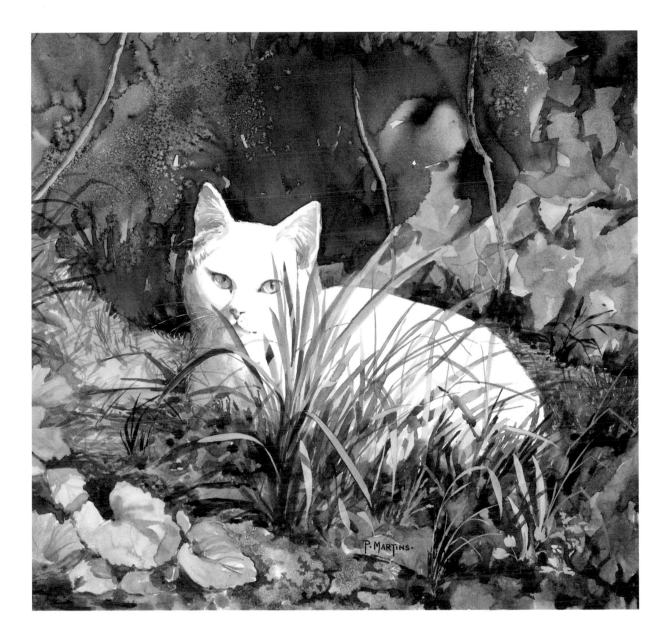

PADS
The Garden Centre Cat

I saw this lovely brown tabby cat when I visited a garden centre one day, looking for some bedding plants to brighten up my garden.

He was dozing on a little patio wall in the warm afternoon air. The staff told me he lives there happily and is fed by the people who run the café on the site. He spends his nights hunting or sheltering among the urns, pots and garden statues. They have called him Pads and everyone spoils him.

I managed to draw him while he slept and later, when he opened his eyes, I saw that they were a beautiful green.

He seemed to be quite an old boy, but no one could tell me exactly when he first appeared. He has patrolled the garden area for years and is a well-known personality at the centre. If a dog appears, however, Pads vanishes. He certainly has plenty of hiding-places!

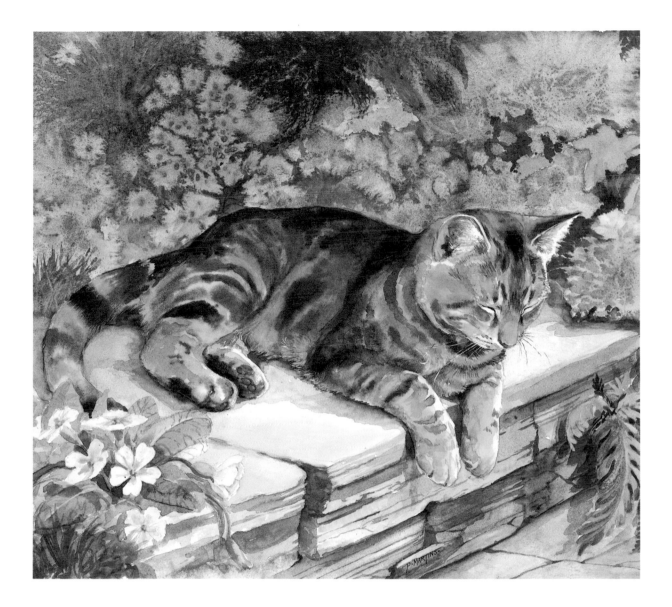

CANDY
Robbie's Cat

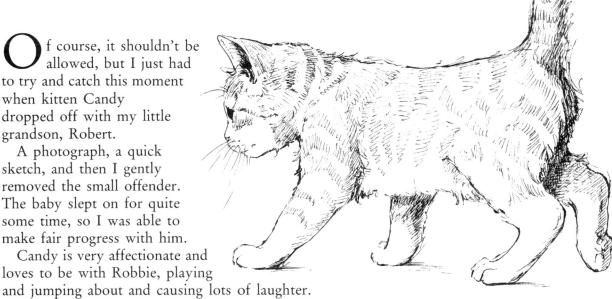

Of course, it shouldn't be allowed, but I just had to try and catch this moment when kitten Candy dropped off with my little grandson, Robert.

A photograph, a quick sketch, and then I gently removed the small offender. The baby slept on for quite some time, so I was able to make fair progress with him.

Candy is very affectionate and loves to be with Robbie, playing and jumping about and causing lots of laughter.

She has four white paws, a very pink nose and a very loud purr.

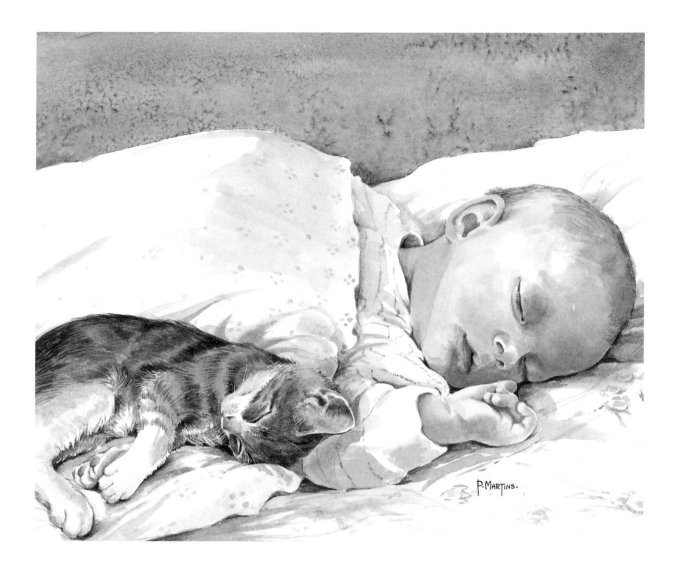

SAFFRON
The Photographer's Cat

Saffron's owner has a shop which sells photographic equipment. I often buy my films there and always look round for Saffron. Sometimes he is there in the shop, but not always. He is a very friendly, semi-fluffy ginger-and-white cat. I first saw him peering with curiosity from behind the glass counter, surrounded by tripods, lenses, light-meters and cameras. On one occasion I found him asleep in an old camera case, a soft padded bag. The photographer told me that he kept this old case especially for Saffron. When I painted him he was snoozing by a potted plant in the room at the back of the shop. It is necessary, I was informed, to move the case occasionally, as Saffron prefers a different location now and then for his daily cat-nap.

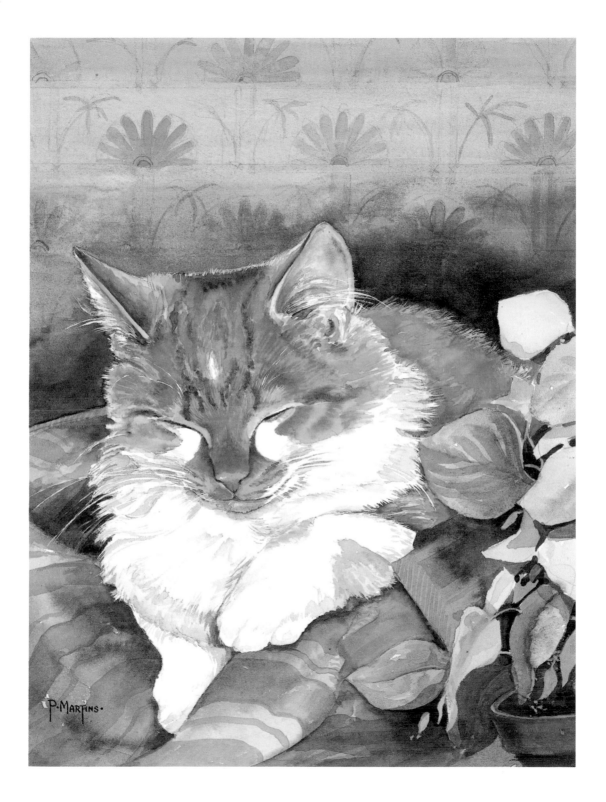

SORREL
The Gallery Cat

Sorrel, who is a beautiful tabby-point Siamese, is very fortunate in having the perfect setting for his refined elegance: he spends his days in an art gallery run by his owner. They arrive by car (Sorrel is a good traveller) and, after a preliminary inspection of the premises, he selects a place for himself, a suitable setting for his long daily sleep. For the rest of the day he may be found lying in a languid pose, tail draped artistically, perhaps on a cushioned chair beneath a misty landscape painting, or on a little table by a still-life of flowers in a Ming vase.

Fortunately he is now a mature cat and can be trusted to behave properly whilst in the gallery, but I am told he lets off steam when he gets home, dashing about and shouting in his loud Siamese voice.

He has a fondness for flowers and will steal just one from a vase without upsetting it, laying his trophy proudly on the carpet.

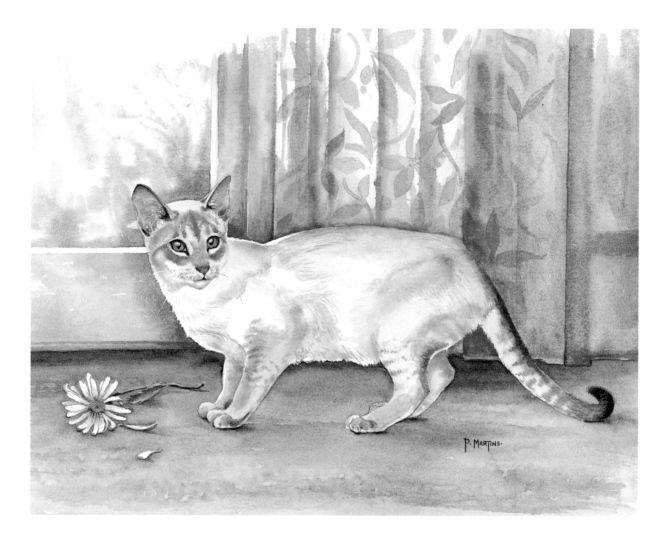

POPPY
The Dressmaker's Cat

Little Poppy is a new arrival in the neighbourhood. She has a soft, fluffy, pale apricot-ginger coat and round orange eyes.

She was adopted by a dressmaker who works at home and therefore has time to be with her little cat in its formative years. Poppy has obviously been well taught, and I felt quite guilty intruding on her more private moments ... I just couldn't resist the look of concentration.

Her greatest delight is to play with the pieces of material, tissue paper and cotton reels while her mistress tries to sew. Once she even managed to dash into the garden with the tape-measure caught up in her fluffy little tail.

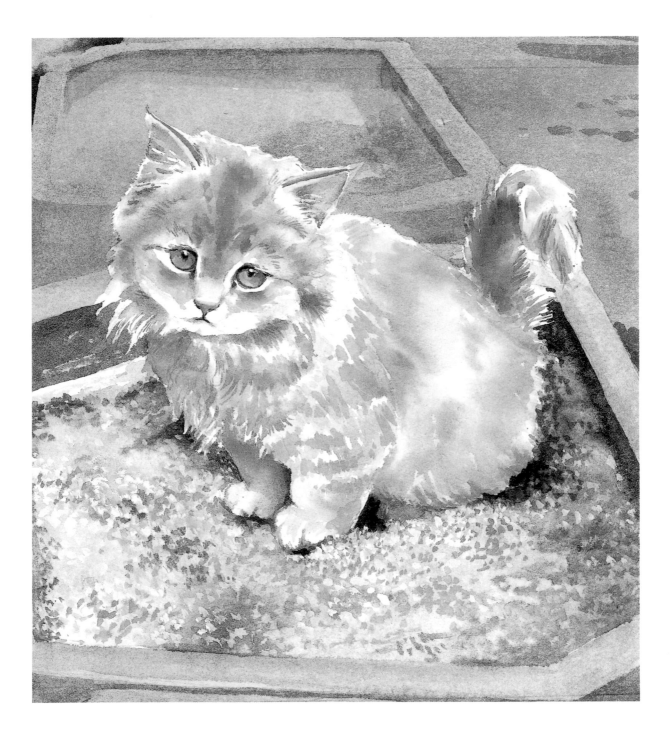

ROSIE
The Old Lady's Cat

Rosie is a very gentle, very shy little cat — tortoiseshell, with lots of white. She belongs to an elderly lady who lives on her own in an old house down a grassy lane. It is all very overgrown and rather wild, but beautiful in the summer months with bees and butterflies in plenty.

I visit the old lady sometimes and always hope to catch a glimpse of Rosie's little white face peering through the weeds. She is a great companion for her owner but is rather afraid of visitors. She was a stray who just arrived one cold, wet evening, at the end of the garden.

It took many weeks of putting out food and gentle coaxing to gain her confidence and persuade her to come inside the house and settle by the warm fire. In the end she blossomed into a very affectionate cat and now she never wanders away from the garden.

38

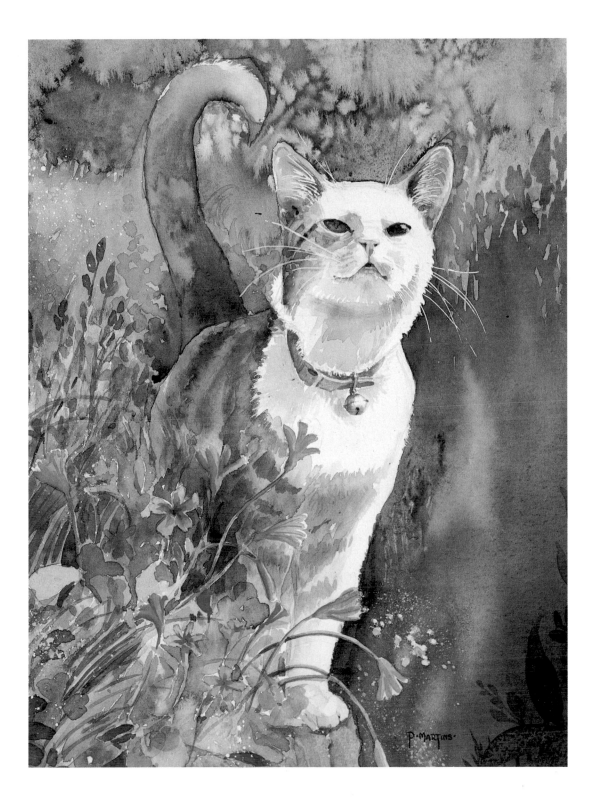

SAM
The Gardener's Cat

Sam is a supervisor! He spends many hours parading up and down the wall which borders his family's garden. His owner is a keen gardener who manages to spend all his free time planting, weeding and cutting grass. Sam has to be there to gaze into any hole, to sniff the new plants and to roll in the grass cuttings — as if he feels he must make sure that all is in order.

From his high perch he can see into two gardens and one wonders if he is comparing notes.

Perhaps one reason for his chosen vantage point is that next door there lives a lively Dachshund!

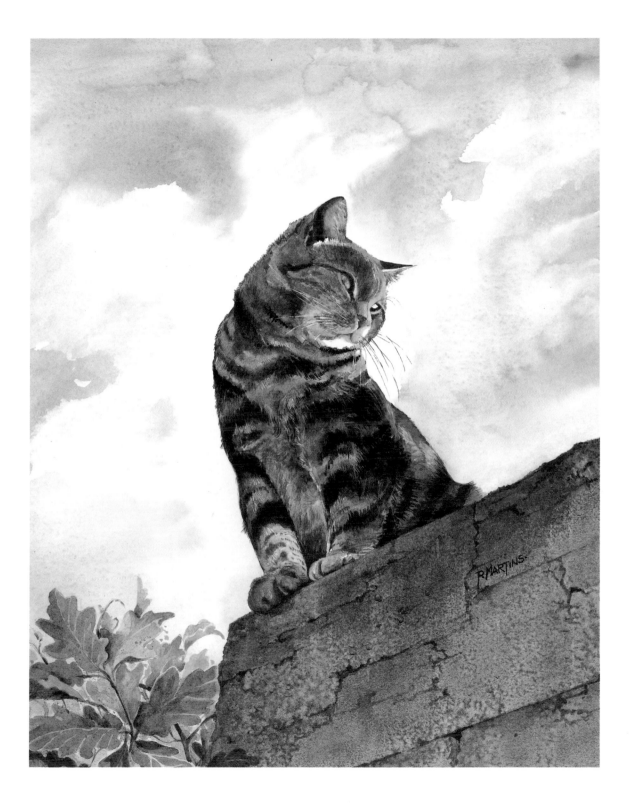

KIZZY & KOPPA
The Students' Cats

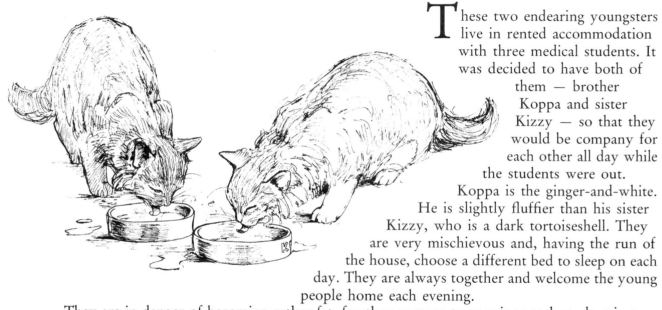

These two endearing youngsters live in rented accommodation with three medical students. It was decided to have both of them — brother Koppa and sister Kizzy — so that they would be company for each other all day while the students were out.

Koppa is the ginger-and-white. He is slightly fluffier than his sister Kizzy, who is a dark tortoiseshell. They are very mischievous and, having the run of the house, choose a different bed to sleep on each day. They are always together and welcome the young people home each evening.

They are in danger of becoming rather fat, for they manage to convince each student in turn that they have not yet had their supper, so that quite often they succeed in putting away three meals in a single evening.

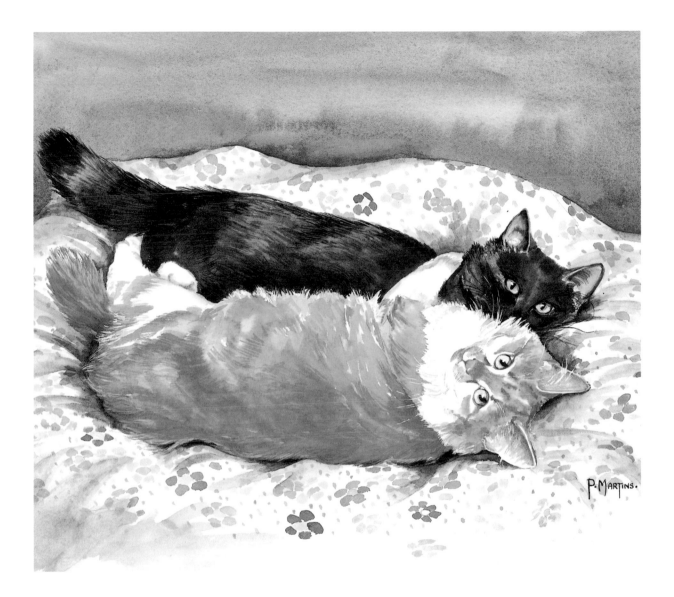

43

BINKS
The Cattery Cat

Binks is about nine years old and her home is with the owners of a boarding cattery. She is a gentle tabby with white legs and shirt-front.

Over the years she has become very used to the continual change-over of cats who come to stay for a few days or weeks, and seems not to mind this constant invasion of her territory.

One part of the cattery is set aside for rescued cats, and sometimes unwanted kittens are found and brought in. Binks will care for them, washing, cleaning and mothering each small bundle.

I saw her resting in a box when I took my own two cats to be boarded for a short while. I took photographs of her and later made this painting. Her expression was irresistible and she was quite unperturbed by my attention.

44

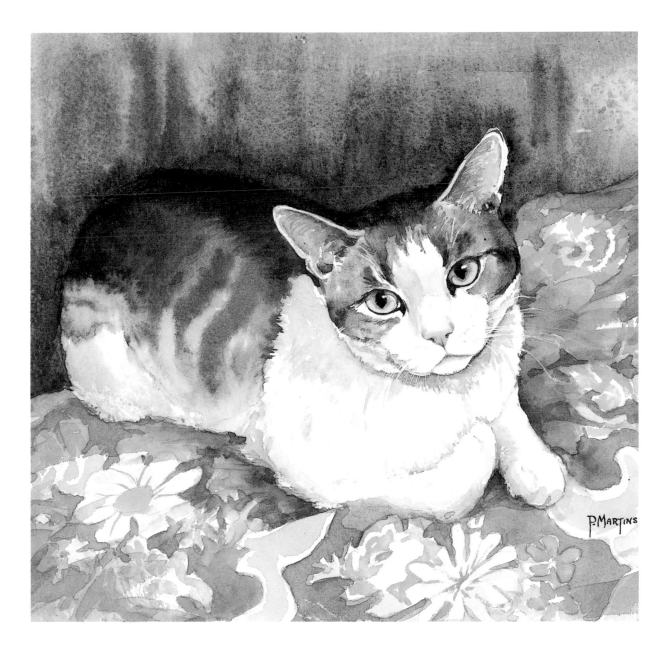

MINNIE
The Painter's Cat

Minnie is my own little Persian beauty. She is three years old and has the longest coat, the shortest nose, the biggest eyes and the bushiest tail I have ever seen.

She is constantly with me and her favourite seat is right beneath my Angle-poise lamp beside my drawing board, where she not only blocks out the light but also distributes long hairs all over my paintings.

Minnie is a great 'poser' and chooses her settings with care in order to be seen at her most beautiful. On the occasion when I painted her she had disturbed the fruit-basket to arrange herself in an artistic manner — with a tasteful touch of colour!

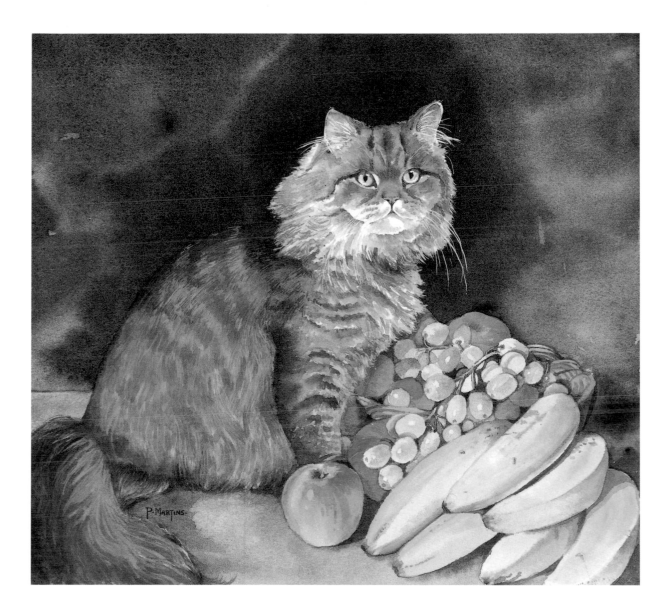

I would like to thank all the friendly
and helpful 'owners' who allowed me to
use their beautiful cats as models for
the paintings in this book.
Thanks also to my cats George and
Minnie, who always sit with me and
spread their hairs over everything.

This edition published 1992 by BCA
by arrangement with Souvenir Press Ltd.,
CN4156

Set by Setrite Typesetters Ltd, Hong Kong
Colour reproduction by Tenon and Polert Colour Scanning Ltd, Hong Kong
Printed in Hong Kong by Dah Hua Printing Press Co Ltd